For Miles,
On his first Xmas
MMVIII.

Edward Gorey

with love.
from
Uncle (honorary) Simon

Pomegranate
San Francisco

Published by Pomegranate Communications, Inc.
Box 808022, Petaluma CA 94975
800 227 1428 707 782 9000
www.pomegranate.com

Pomegranate Europe Ltd.
Unit 1, Heathcote Business Centre, Hurlbutt Road
Warwick, Warwickshire CV34 6TD, UK
[+44] 0 1926 430111
sales@pomeurope.co.uk

An **Edward Gorey®** licensed product
© 1983 Edward Gorey
Published under license from The Edward Gorey Charitable Trust

Library of Congress Control Number 2008922702
ISBN 978-0-7649-4597-7

Pomegranate Catalog No. A150

Designed by Lisa Reid

Printed in China

17 16 15 14 13 12 11 10 09 08 10 9 8 7 6 5 4 3 2 1

Homage to
Mrs Barbauld

The Eclectic Abecedarium was Edward
Gorey's first miniature book. The text is
patterned after early moral primers
for children. The original drawings
measure 5/8 x 1 inch. They have been
slightly enlarged for this edition so that
even the aged and otherwise hard-of-
seeing can benefit from Mr. Gorey's
sage advice.

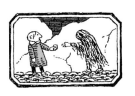

Betray no qualms
When asked for Alms.

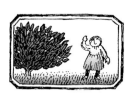

A hidden Bird
Is often heard.

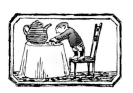

Pick up loose Crumbs
Upon your thumbs.

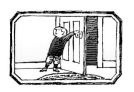

*Look back before
You close a Door.*

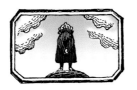

There is an Eye
Up in the sky.

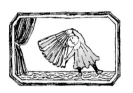

It takes elan
To wield a Fan.

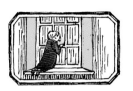

Beyond the Glass
We see life pass.

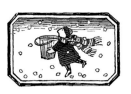

For catching Hail
Keep by a pail.

Be loath to drink
Indian Ink.

Don't try to cram
The dog with Jam.

In sorting Kelp
Be quick to help.

Forbear to taste
Library Paste.

Be sure a Mouse
Lurks in the house.

A careless No
Leads on to woe.

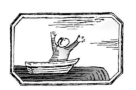

Don't leave the shore
Without an Oar.

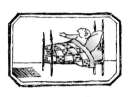

Request a Pill
When you are ill.

Find tasks to do
While in a Queue.

Attempt to cope
With tangled Rope.

See down the Sun
When day is done.

On any road
May sit a Toad.

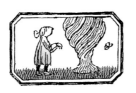

Don't overturn
The garden Urn.

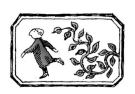

Beware the Vine
Which can entwine.

The way to Hell
Is down a Well.

The letter X
Was made to vex.

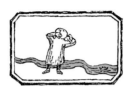

With every Yawn
A moment's gone.

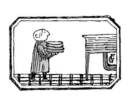

The kitchen sink
Is made of Zinc.

Edward Gorey publications by Pomegranate:

BOOKS

Category

The Twelve Terrors of Christmas, text by
 John Updike

The Wuggly Ump

The Sopping Thursday

The Gilded Bat

The Hapless Child

*Elephant House; or, The Home of Edward
 Gorey*, by Kevin McDermott

SPECIALTY ITEMS

Edward Gorey's Dracula: A Toy Theater

Verse Advice Birthday Book

The Fantod Pack

PLUS

Edward Gorey calendars, notecards, jigsaw
puzzles, postcards, and much more